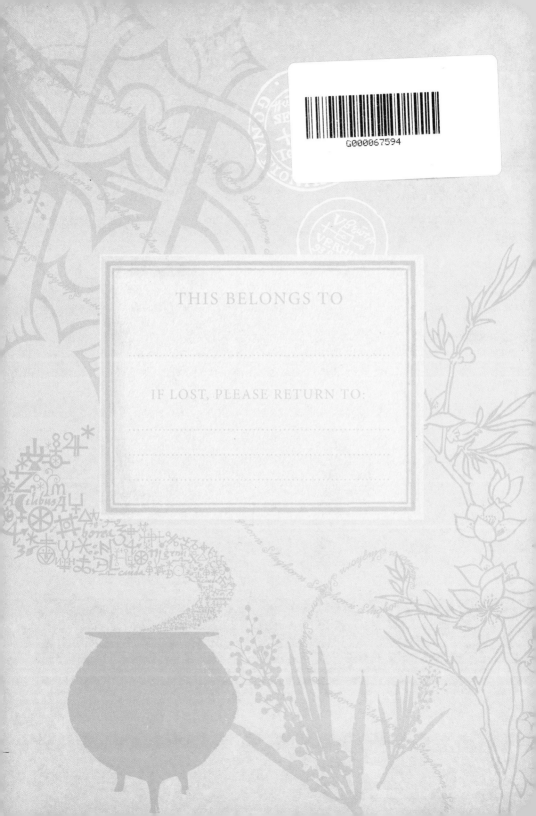

THIS BELONGS TO

...

IF LOST, PLEASE RETURN TO:

...

...

G000067594

WIZARDING WORLD and all related trademarks, characters,
names, and indicia are © & ™ Warner Bros. Entertainment Inc. (s23)

INSIGHTS

www.insighteditions.com

MANUFACTURED IN CHINA

10 9 8 7 6 5 4 3 2 1